IMAGES
of America

MADISON

The Broadway Fountain, located at Main Street and Broadway, has over the years become symbolic of historic Madison. Cast by the Janes, Kirtland and Company Iron Works of Morrisianna, New York, the fountain first appeared at the 1876 Philadelphia Centennial Exposition. Several years after the exposition closed, it was purchased by the local lodge of the International Order of Odd Fellows, who presented it to the City of Madison as a gift. In the late 1970s, it was completely recast in bronze after deteriorating beyond repair, and it underwent major cleaning in 2004. Today the beautiful landmark is a popular backdrop for weddings and the site of outdoor concerts. A duplicate of the fountain is in Forsyth Park in Savannah, Georgia.

On the front cover: Please see above. (Courtesy Jefferson County Historical Society.)

IMAGES of America
MADISON

Ron Grimes and Jane Ammeson

ARCADIA
PUBLISHING

Copyright © 2006 by Ron Grimes and Jane Ammeson
ISBN 0-7385-4064-1

Published by Arcadia Publishing
Charleston SC, Chicago IL, Portsmouth NH, San Francisco CA

Printed in the United States of America

Library of Congress Catalog Card Number: 2006922112

For all general information contact Arcadia Publishing at:
Telephone 843-853-2070
Fax 843-853-0044
E-mail sales@arcadiapublishing.com
For customer service and orders:
Toll-Free 1-888-313-2665

Visit us on the Internet at http://www.arcadiapublishing.com

Through the years, Madison has had the good fortune to be the home of many talented photographers, both professional and amateur. From early daguerreotypist Joseph Gorgas to contemporary amateur photographer Dr. Robert Snodgrass, each generation has captured in pictures the people, the architecture, the events, and the scenes of daily life in this historic city. The extensive photograph collections from which the images in this book were selected also include the works of late-1800s photographers William Heberhart, John Cadwallader, Harry Miller, George Spaulding, and Lida Hutchings. In the 20th century were Herbert Flora, Louis Cohen, Charles Kahn, and Harry Lemen. This book is dedicated to these and all the other photographers who have left us priceless glimpses of our past.

Contents

Acknowledgments		6
Introduction		7
1.	On Main Street	9
2.	The Riverfront	27
3.	Making A Living	43
4.	Having A Good Time	59
5.	Indiana's Pioneer Railroad	75
6.	Going to War	81
7.	Churches and Schools	87
8.	Serving the Community	101
9.	Getting Around	109
10.	People and Places	117

Acknowledgments

The authors would like to thank the Jefferson County Historical Society Research Library and the Madison-Jefferson County Public Library for permitting the use of their extensive photograph collections from which the majority of the photographs appearing in this book were selected. Local history librarian Janice Barnes at the public library was most helpful and knowledgeable in working with their Harry Lemen Photo Collection. It should be noted that the Madison-Jefferson County Public Library has embarked on an ambitious project to make available for viewing on the Internet the Lemen Photo Collection and also a fine collection of historic steamboat and railroad images. Hundreds of vintage images can today be seen via their Web site, www.mjcpl.org.

We would also like to thank Historic Madison, Inc. (HMI), for the use of photographs from their Lida Hutchings Photo Collection and to express our appreciation for the guidance and counsel of HMI director of programs Kimberly Nyberg, whose extensive knowledge of Madison history and architecture was most valuable. Since 1960, HMI has been devoted to preserving the unique architecture of Madison and to educating the public through their museum properties. HMI was instrumental in the success of establishing downtown Madison as a National Historic Landmark District.

We thank the many individuals who permitted the use of treasured photographs from their personal collections and in particular, Kenneth McLain, who has shared with the Jefferson County Historical Society nearly 300 postcard images of Madison scenes from his extensive personal collection.

Finally a word of deep appreciation goes to Jacqueline Grimes for her assistance in researching the photographs, editing the captions, and being so patient and understanding. Appreciation also goes to Charlie, Evan, and Nia Ammeson for being supportive and patient during this endeavor.

INTRODUCTION

Settled while Indiana was still a territory, Madison, tucked among the rolling hills that meander toward the Ohio River in southeastern Indiana, was established in 1809. Considered a major river port and supply town outfitting pioneers as they made their way into the Northwest Territory, Madison thrived during the steamboat era. Showboats filled with entertainers stopped at Madison, steamboats brimmed with visitors and locals taking excursion trips, and barges and ferries all made their way up and down the river using the city as a stopping point. Railroading in Indiana first started with the building of the Madison and Indianapolis Railroad, which brought new trade and prosperity to Madison in the 1840s and revolutionized travel to the heartland of the state. Pres. Andrew Jackson came to Madison in 1829, Pres. James Polk in 1835, and Pres. Herbert Hoover in 1929; famed opera singer Jenny Lind, known as the Swedish Nightingale, performed here in 1851; and Charles Lindbergh arrived in 1956.

The city's first store was opened by Col. John Vawter on the corner of Main and Jefferson Streets, adjacent to where the magnificent Greek Revival county courthouse, completed in 1855, still stands. Soon there were sawmills, foundries, shipyards, newspapers (the second paper published in the Northwest Territories was published in Madison), warehouses, breweries, slaughterhouses (long before Chicago became the livestock capital, Madison was known as "Porkopolis"), saloons, family-run groceries, and so much more.

But as steamboats and railroads gave way to cars, busses, and trucks, Madison began to languish as it was passed by. Many of the buildings in Madison, dating back to those magnificent times from the 1830s to the early 1900s, were never torn down to make way for "progress." The old wood and brick structures, wonderful examples of Federal, Greek Revival, and Italianate residential and commercial buildings, were left as is. This neglect became a historian's boon.

Now, because of the city's dedication to its past, Madison has returned to those glory days. The city's historic district, which contains over 1,600 buildings, was in 2006 designated as a National Historic Landmark District, placing it in the company of such distinguished cities as Savannah, Georgia, and Charleston, South Carolina.

New businesses inhabit many of the renovated buildings. What was once the home of Charles Schussler, a Civil War surgeon, is today an immaculately restored bed and breakfast. Others retain their origins stretching back for many generations. Founded in 1917, Mundt's Candies still uses much of the original equipment to make their famous candy fish, along with a plethora of chocolate confections, and sells the goods in their vintage confectionery shop, restored to its early 1900s appearance.

Other buildings are preserved as if in amber, beckoning visitors to view life as it was lived in the city's early days. The apricot-colored Lanier Mansion—with its two-story, white Corinthian columns; octagonal cupola; and such unique interior features as curved doors that fit into the rounded walls—is considered, according the Indiana State Museum, one of the best surviving examples of Greek Revival architecture in the country. The home, with its elaborate formal gardens leading down to the Ohio River, was built by James Franklin Doughty Lanier in 1844. Lanier, a successful businessman and railroad financier, was also brave and resourceful. At one

time, knowing that there was to be a huge financial panic that might destroy his bank and his city, he is said to have ridden alone on horseback from Madison to Washington, D.C., with over $1 million in currency and gold packed in his saddlebags.

Take a walk back into time by visiting the Ben Schroeder Saddletree Company, now operated as a museum by HMI. This longtime Madison business crafted tens of thousands of wooden frames for saddle makers that were sold in this country and Latin America.

The home and offices of Dr. William Hutchings, a horse-and-buggy doctor, were closed after his death in 1903 and not opened again for almost 70 years. His office is now a museum, allowing us to step into his history and that of all small-town doctors. Other historic homes that belonged to families who defined Madison—those of the Schofields, Costigans, Sullivans, and more—are now house museums providing glimpses of the past.

There are magnificent commercial and public buildings as well. The 1895 railroad station, restored by the Jefferson County Historical Society, is now a museum telling the story of Indiana's pioneer railroad. Churches with soaring spires and steeples that date back to the mid-1800s, the Second Empire Masonic temple on Main Street, the Victorian commercial downtown storefronts, and the neoclassical Elk's Club building, with its two-story arched doorway and proud elk head at the roof, are just a few of the edifices that make Madison unique.

It is these stories about the people and the buildings they left behind that make the city such a unique jewel. To visit today's Madison, named by the National Trust for Historic Preservation as a Distinctive Destination, is to connect to yesterday.

One
ON MAIN STREET

This 1850s view of the intersection of Mulberry Street and Main Street (then known as Main-Cross) looks east and is one of the earliest photographs of Madison. The surrounding hills have been cleared of trees by lumbering. The city's dirt streets were often muddy or dusty depending on the weather, and livestock was often herded down the major streets to the local packinghouses.

UNION BREWERY, P. WEBER, PROP'R.

Bird's-eye-view maps, popular in the Victorian era, promoted towns and their businesses and were used to instill civic pride and encourage commercial growth. This map of Madison in 1887 was published by the J. Wallis Smith and Company of Delaware and was distributed in Madison by the businesses featured on the map. A close look at the map reveals the numerous factories

10

located on the riverfront, and Main Street with the horsecar line, which branched up Walnut Street. The two buildings enlarged in the upper right corner of the map still exist today. The Madison Brewing Company building is now a moving company. On Main Street, the Niklaus Wholesale Grocery Company is known today as the Scott Block building.

This c. 1910 postcard shows downtown Madison, looking west down Main Street from the side of Telegraph Hill where the Hillside Hotel was later built. Note the old car added by the postcard artist. The automobile was still a novelty in Madison and had to compete with the horse and buggy on the dusty, unpaved streets of the town.

The Hillside Hotel, built in 1924, was owned by Madison physician George E. Denny, who announced four years after it was built that he was going to almost double the size of the hotel. During the 1940s, rooms rented for $2.50 a night and dinners cost 85¢. The hotel was destroyed by fire in 1964 and replaced in 1966 by the present Hillside Inn, which has recently undergone total renovation.

The Hoffstadt family gathered for this early-1900s holiday picture on the front porch of their home at 521 East Main Street. Juliet, Rachel, and Etta—the young girls in the photograph—later became noted citizens in Madison. Juliet became a research librarian, Rachel a university professor, and Etta a Madison schoolteacher. Both Etta and Juliet were also artists who made and sold some 600 collector dolls.

The City Market House, built in 1851, was located at the southwest corner of Main and Walnut Streets. It was one of four such market houses in Madison where produce, meat, dairy, and other farm products were sold. In the early days, an inside stall rented for $20 a year, while a bench outside was $7. The market was demolished in 1907 for the construction of a war monument that remains today.

The Danner Grocery occupied this building on the southeast corner of Main and Walnut Streets in the early 1900s. It was built in 1851 as the Indiana-Kentucky House Hotel. The hotel featured lighting with artificial gas, new to Madison at the time. In the 1920s, John Sample operated a feed and grain store in the building. It has recently been renovated and returned to its original configuration.

This view looks west on Main Street from atop the Danner Grocery building during the 1919 fall festival. Tin Lizzie automobiles lined the middle of Main Street for five blocks during the popular event. The Fischer Carriage and Wagon Company (right in photograph) would soon be out of business as the automobile grew in popularity.

This rare view of the Jefferson County Courthouse was taken shortly after its construction in 1855. The third courthouse built at Main and Jefferson Streets, this magnificent Greek Revival–style building cost $36,000. Several years later, a fire started in Judge Joseph Chapman's chambers and destroyed the upper portion of the building. When the fire damage was repaired, the roof was rebuilt with the steeper pitch that is seen today.

In this photograph taken on a cold day in February 1915, Jefferson County circuit court judge Francis Marion Griffith sits, wearing his overcoat, in his courthouse chambers. He is meeting with county prosecutor Wallace J. Cotton (in back). Note the wallpaper on the ceiling, a style of decorating popular in the Victorian era.

The Gertz City Bakery and Lunchroom was located on the northeast corner of Main and Jefferson Streets, across from the courthouse. Charles Gertz established the business at this location in 1863, and his son George Gertz (on steps in center) continued to run it. Look carefully at this 1889 photograph and one can see several pigs wallowing in the street gutter.

In 1928, the bakery at Main and Jefferson Streets was torn down and replaced by this Mobil service station. The Thomas Ford dealership next door lined up its inventory of new Model A cars in front of the courthouse for this unique time-lapse photograph taken at night. Many other corners on Main Street became service stations in the 1920s as the automobile replaced the horse and buggy.

Harper's Drug Store was located on the northwest corner of Main and Jefferson Streets. Founded by John Harper in 1845, it was one of the oldest businesses in Madison when this 1927 photograph was taken. At the far right in the photograph is one of the illuminated traffic islands placed in the middle of the major Main Street intersections in the early 1920s. The islands displayed street names and advertising panels.

This early-1900s view of the cluttered interior of Harper's Drug Store shows owner Frank Harper behind the cash register. Across the aisle, a display case offers a fine selection of cigars. The store moved to another location in 1946 and closed in 1980 after being in business for 135 years. The third floor was later removed, and the building is used today as a bank office.

This 1880s view looks east on Main Street from Mulberry Street. The Doric columns identify the National Branch Bank, founded in 1846. Next door is the stately Masonic temple building. Described as an outstanding example of Second Empire architecture, the Masonic temple was designed by John Temperly in 1871. Recently restored, it is now a Main Street showpiece. Note at the far right the advertising signboard with a clock.

The same view as in the photograph above, this image was taken 60 years later in the early 1950s. Where buggies once parked, Main Street is now lined with shoppers' automobiles. Visible to the far right in the photograph is the sign of the Inglis Drug Store, then located on the southeast corner of Main and Mulberry Streets in a 1911 building that was originally a department store.

This late-1800s view looks east on Main Street from West Street. Visible in this busy street scene, photographed by Madison resident Lida Hutchings, is a hay wagon passing through town. Further up the street is a mule-drawn streetcar that has just passed a "turnout," a short stretch of double tracks on the single-track line where the streetcars could pass each other. (Courtesy Historic Madison, Inc.)

Seven decades later in this 1950 postcard view of the same scene, the vehicles have changed considerably, but the historic commercial buildings in downtown Madison remain the same. One change is the Ohio Theatre, visible to the left in the photograph, completed in 1938 on the site of an old nickelodeon. The marquee features Ginger Rogers, starring in *Perfect Strangers*. Renovated in 1996, the theater still entertains Madisonians today.

Main Street provided the sets for the 1958 filming of the movie *Some Came Running*. A crowd gathers to watch the filming outside a jewelry store across from the Ohio Theatre. Hundreds of people from all over Jefferson County thronged the streets while the movie was being made, many being used as extras.

In this publicity photograph, from *Some Came Running*, from left to right are Martha Hyer, Dean Martin, Shirley MacLaine, Frank Sinatra, Nancy Gates, Arthur Kennedy, and Leora Dana. Although most of the cast enjoyed their stay in Madison, Sinatra did not. Stories are told that he was often seen intoxicated and once shouted that he was "leaving this crummy little burg and all the hicks that are in it." (Courtesy Harold Lakeman.)

This view of Main Street looks west from West Street in the late 1800s. To the right is the Powell and Weyer hardware store. It was later a furniture store, and today the restored building has been converted to apartments with a coffeehouse on the ground floor. Note the advertisement on the building for the Sells Brothers Circus and Pawnee Bill's Wild West Show. (Courtesy Historic Madison, Inc.)

To the far left in this 1927 photograph is the W. Mundt Candy Store at 207 West Main Street, which was opened by candy maker Walter Mundt in 1917. The confectionery was known for its famous fish candies, which became a holiday favorite. Today under new ownership, candies are still made in the same third-floor candy kitchen in the same 1800s building, using Mundt's original equipment. (Courtesy Dorothy Jones.)

A Madison institution, Hinkle's Sandwich Shop at 204 West Main Street first opened for business in 1933 next door to Geile Brothers' poolroom (on the right) and Reed's Laundry. Hinkle's, the oldest restaurant on Main Street, was at one time a franchise with locations in Linton, Indianapolis, and Bloomington. A fire in 2000 nearly destroyed Hinkle's, but it has since been rebuilt, right down to the neon sign.

The Taylor-Hitz Company was located at 312 West Main Street. A flour mill was located there from the 1850s, and a bakery, which produced 75 barrels of crackers and 2,000 loaves of bread daily, was added in 1884. The baked goods were then sold in Madison and nearby towns by traveling salesmen. With the third floor removed, the building today is a retail store.

Looking east from Main and Poplar Streets, this 1927 photograph shows the Grand Movie Theater. Originally the Grand Opera House, it was built in 1885 by adding a new front onto an old church building. Over the years, vaudeville stars such as Will Rogers and Buster Keaton performed there, and it introduced "talking pictures" in 1929. It was demolished in 1960 for construction of a city parking lot.

The southwest corner of Main Street and Broadway has been a service station since the 1920s, when the new Storm's Gas Station replaced an old office building. Next to it in this 1927 photograph is the Broadway Hotel, which opened in 1834 and is still in business today. The menu in 1859 included oysters, fresh fish, and game, and services included care of horses at the livery stable next door.

Known today as the Trolley Barn, this building at 719 West Main Street was constructed in 1875 as a farmer's market house. In 1896, the Madison Light and Railway Company converted it into an electricity generating plant, providing power for the trolley system and the city's residents. The generating plant closed in 1965, and the building became home to several specialty shops in 1972. (Courtesy Nora Guth.)

Vincent's Grocery, one of the larger mom-and-pop stores, occupied two storefronts on the southeast corner of Main and Mill Streets. Many longtime Madison residents fondly remember Thomas P. Vincent (fifth from the left), who patiently waited as customers selected their penny candy. A gift and coffee shop operates in the building today. In this 1930 photograph, bread is priced at 8¢ and coffee 20¢ a pound. (Courtesy the Attic.)

The Union Brewery, located on the northwest corner of Main and Vine Streets, was established in 1862 by German immigrant Peter Weber. With the growth of the business, he built this magnificent new building in 1876 to house the latest in brewing equipment. Note the huge wooden holding tanks on the street, awaiting installation. With the onset of Prohibition, the brewery closed, and the building became the Hampton Cracker Company, "Home of Crackin' Good Crackers." Later used as a container factory, it was destroyed by fire and replaced by the present single-level building.

Streetcars first appeared on Main Street in 1873, drawn by horses and mules. This photograph was taken at the west end of the one-track line, where the cars were turned around on a turntable. To the chagrin of the driver, young pranksters often piled onto the rear platform, causing the lightweight cars to tilt backward off the tracks.

When the streetcar system was electrified in 1898, the line was extended west on Main Street to the Beech Grove Park, where the annual Chautauqua was held. This early-1900s postcard view shows a trolley car crossing the bridge over the Madison Incline, heading back to downtown Madison. A banner on the trolley pole advertises an upcoming event at the park.

Two
THE RIVERFRONT

Visible in this 1880s view of the Madison riverfront are the buildings of the Trow Flour Mill, one of the many factories that lined the riverfront, at Broadway and Front Street. During the steamboat era, Madison was a major port as boats made their way up and down the Ohio River, connecting to the Mississippi River and the Gulf of Mexico. Showboats and excursion boats also stopped in Madison, providing entertainment for Madisonians.

The Madison riverfront bustled with activity when the riverboats docked. A description of the riverfront said that it was a "chaotic place with inebriated river men, fast women, escaped livestock, muddy streets and music emanating from the dance halls and saloons." Steamboat traffic on the Ohio River reached its zenith in the 1850s, and such luminaries as Henry Clay, William Henry Harrison, and Zachary Taylor stopped here during this time period.

The excursion riverboat *Homer Smith* has just docked at the Madison Landing in this 1916 postcard. Riverboats brought many famous people to Madison including Pres. Herbert Hoover, who stopped in Madison at the foot of West Street on a trip between Cincinnati and St. Louis. The visit ended sadly when a cannon salute on Telegraph Hill misfired, killing the young man who was operating it. (Courtesy Kenneth McLain.)

The Madison Dike curved out and downstream from the Kentucky bank to the center of the Ohio River. Nearly a half-mile long, the stone rubble structure, also known as a wing dam, directed the river flow to create a deep channel for navigation. It was a popular spot for fishing and strolling. The dike in this early-1900s snapshot is today submerged below 12 feet of water.

"I think we hit the dike!!" said Capt. Lucien E. Bowen on June 18, 1894, according to an account written by local historian Dorothy Darnall Jones. Bowen was piloting the *City of Madison*, returning to Cincinnati from Louisville when it rammed the dike at 4:00 a.m. It sank in the shallow water, damaged beyond repair. Ironically it was built in Madison, piloted by a Madisonian, and sank at Madison.

Grand interiors were part of the draw of the riverboats that made their way up and down the Ohio River. One such example was the *City of Madison*, a side-wheel packet boat with 56 staterooms and three decks, built at the Madison Marine Shipyard in 1882. By the time the steamer was furnished, its cost was about $50,000.

An excursion group in this early-1900s photograph gathers on the deck of the *Falls City* as it departs Madison. From 1898 to 1916, it was one of many excursion boats offering daytime rides for families with children and also moonlight rides that left the wharf at 9:00 p.m. There were ballrooms for dancing, promenades with secluded benches for romancing, and even a holding room for the overly boisterous.

The showboat *Goldenrod*, which had just docked at Madison in this 1936 photograph, featured *Major Bowes Amateurs Show*, a radio show during the 1930s and 1940s. Two years after Bowes's death, a talent scout named Mack, who had worked for Bowes, revived the show, calling it *Ted Mack and the Original Amateur Hour*. Showboats were frequent visitors to Madison.

Although it looks like the navy just arrived, it is really members of the band from the showboat *Cotton Blossom* performing on Main Street at Mulberry Street in 1927 to promote their show. Note the sign for the Inglis Drug Store. In 1914, John Inglis moved his 26-year-old drugstore from Milton, Kentucky, to this location. Its soda fountain became a popular meeting place.

The Middleton-Wymond Coal Company elevator, located just east of Cragmont Street, was one of several along Madison's riverfront in the 1890s, when this photograph was taken. Coal was unloaded from the barges into small carts that were drawn up the elevator by cables. In the foreground, lumber is being off-loaded from the barge onto a dray to be taken to one of the nearby lumberyards.

Wagons laden with tobacco wait in a line past the Red Onion Saloon on the riverfront in this 1920s photograph; each will deliver its load to one of the five tobacco auction warehouses along the riverfront. Records show that tobacco was being processed in Madison even before 1850, partly because Madison had a thriving cigar manufacturing trade, which flourished into the early 1900s.

An early daguerreotype shows the floating studio of Madison photographer Capt. Joseph Gorgas, who on this boat brought his trade to towns along the Ohio River for several years. Gorgas came from Pennsylvania to Madison in the early 1850s and soon established himself as a "pioneer artist in his line." Some of his portrait pictures hang today in the city council chambers of city hall. (Courtesy Frank Gunter.)

A close look at this snapshot reveals something missing—no smokestacks! The *Levi* was powered by two mules walking a treadle that connected to the stern wheel. Built and operated by Edward Turner at Plow Handle Landing, the unique boat made daily trips to Madison hauling passengers, livestock, and groceries. After five years, the slow-moving *Levi* was refitted with a faster gasoline engine. (Courtesy Louis DeCar.)

The ferryboat *Trimble* passes the night ferry wharf boat as it crosses from Milton, Kentucky, to Madison. Until the completion of the Madison-Milton Bridge, ferries were the only means of getting a wagon or automobile across the Ohio River between Cincinnati and Louisville. At night, the *Trimble* docked and the small night ferry carried only passengers across the river.

At the Madison dock, horse-drawn wagons and buggies drive off the deck of the *Trimble*. Kentucky farmers needed the ferry to bring their products to Madison mills and markets. The three young girls in this 1910 photograph might have crossed the river by rowboat rather than paying the ferry toll.

In late 1927, Madison officials were approached by a Chicago promoter who offered to build and operate a bridge across the Ohio River at no cost to the taxpayers. Quickly approved by the city and Congress, it was not until August 1928 that the War Department gave their approval. Work then began with construction of the concrete piers, which rest on solid rock 68 feet below the low watermark.

A little over a year later, as America was slipping into the Great Depression, the last steel beams were lowered into place, followed by the laying of the concrete roadway. In this ironic photograph, the ferryboat passes under the nearly completed bridge that will put it out of business. In its last years of ferry service, the *Trimble* was converted to a barge and pushed by a modern towboat.

When the bridge opened, it provided a direct route from Indianapolis, Indiana, to Lexington, Kentucky, on what is now U.S. Route 421. A tollbooth at the north end of the bridge collected a 50¢ toll. The State of Kentucky purchased the bridge in 1937 at a cost of $1,365,000. Tolls were eliminated 10 years later, followed by a "Freeing of the Bridge" celebration, and the tollbooth disappeared.

This Greyhound bus filled with dignitaries was the first vehicle to cross the Madison-Milton Bridge after the dedication ceremony conducted by Indiana governor Harry Leslie. Touring Madison after the ceremony, the bus turned north at Main Street and Broadway to pass by the Broadway Fountain. A Madison police officer directs traffic at the busy intersection. In the background is the Nathan Powell residence.

The dedication and grand opening of the Madison-Milton Bridge was held on December 20, 1929, in the midst of a bitter cold spell. Large crowds lined Main Street for a grand opening parade with 35 floats from Madison and many other communities. During the parade, Madison was showered with 100,000 congratulatory leaflets that were dropped from 10 airplanes traveling to Madison from Indianapolis for the event.

The Madison Marine Railway and Shipyard opened on the Madison riverfront in the early 1850s and continued in business until steel hulls replaced wood in the construction of riverboats. Located just east of what is now a golf course, the shipyard built and repaired hundreds of riverboats. Visible in this 1893 photograph are six riverboats pulled up the sloping railways into dry dock for repairs.

The 1918 ice jam was considered to be the worst in Madison history because the thermometer stayed below zero for much of the winter. This photograph shows the ferryboat *Trimble* trapped in ice as the Ohio River froze over. The frozen river destroyed many boats including the *Princess* and the *Island Queen*. As the ice began melting, people reported hearing sounds of cracking and crashing as the ice moved downstream.

Ice again covered the Ohio River in the winter of 1945. The people shown in this photograph, taken from the Kentucky bank, are enjoying a once-in-a-lifetime experience of walking across the mighty Ohio River. In the background is the J. F. D. Lanier Mansion, a state historic site that was designated a national historic landmark in 1994 and is today open to the public for tours.

Through Madison's long history, the Ohio River has flooded many times, inundating the riverfront streets and buildings with water. During the 1913 flood, pictured here, water swamped Front Street (Vaughn Drive). It is said that as the water rose into the Western Hotel, visible behind tree in the photograph, poker players at the regular card game held there stopped just long enough to move their table up to the second floor.

An aerial view shows how far the Ohio River rose during the 1937 flood, the worst in Madison's history, which not only wiped out Madison's riverfront but also flooded north of First Street for the first time. Flooding also caused Crooked Creek to overflow, putting much of Springdale Cemetery (visible to the far left of the photograph) under water and damaging buildings along its banks in the north part of Madison.

Although it sits on a slight rise one block from the riverbank, the J. F. D. Lanier Mansion—built by financier J. F. D. Lanier in 1844—suffered water damage on its first floor during the 1937 flood. Many riverfront buildings and businesses were lost in the flood and never rebuilt. The riverfront seen today with its beautiful scenic park and walkway bears little resemblance to the smoky bustling industrial avenue it once was.

This photograph, looking west from the J. F. D. Lanier Mansion on First Street, shows the waters of the 1937 flood at the level of the windows of the Madison railroad station. Further down the street, a stranded freight car sits on the track that ran in the middle of First Street. Railroad freight shipments to and from Madison were halted, disrupting business for many months.

In this photograph looking north from the Main Street bridge, a locomotive stops just before the tracks disappear under the floodwaters of Crooked Creek. To the south of the bridge were oil storage facilities and factories that depended on the railroad. Until the floodwaters receded, this became the temporary end of the line, and arriving goods had to be off-loaded there and moved by wagon or truck to their destination.

In 1945, floodwaters from the swollen Ohio River again flowed over the riverfront, this time rising above the first floor of the Crystal Beach Pool building and also the newly expanded Brown Gymnasium. Floods in 1964 and again in 1997 caused damage to the Crystal Beach building and to the other few remaining buildings along Vaughn Drive.

There was excitement on the riverfront in 1918 when the "Flying Boat" *Cincinnati* made an unscheduled landing on the Ohio River at Madison to make some engine repairs. In May 1919, near the end of World War I, the navy's NC-4 Flying Boat, similar to this one, made world news with the first successful transatlantic flight, long before Charles Lindbergh made his famous solo flight.

Sylvester "Darby" Davis and his wife Bertha Mae sit on the riverfront watching the *Island Queen*, described by the *Madison Courier* in 1937 as a "palatial glass-enclosed steamer," which has just docked at Madison. The couple lived on a shanty boat on the river, visible to the right of the photograph. A resident of Madison for 50 years, Darby worked as a blacksmith, boat tender, and fisherman.

Three

MAKING A LIVING

Sitting on a pile of discarded mussel shells weighing nearly 40 tons are employees of the Potter Button Company factory from 1913. From left to right, they are Edward Sliemaster, Commodore Potter, William Potter, H. Sheets, Goose Emel, and Charlie Hugeback. At one time, Madison was the national center for pearl button production, as the Ohio River was abundant with mussel beds. A good day's catch could yield two tons of shells, which sold for $18 to $20 a ton. In 1913, there were two other button-cutting plants in Madison, but all eventually went out of business as the mussel beds became depleted.

The Madison Brewing Company, founded in 1881, was located at the east end of Madison in a building now occupied by a moving and storage company. Their XXX Ale was so popular that it was even sold in New Orleans. It was built on the site of the old Salmon Brewery, established in 1823. The ale's success was attributed to the local spring water said to impart a fine flavor.

Sam Herin's Livery Stable, located at 111 East Second Street, was considered to be one of the finest livery and sale stables in southern Indiana. Herin was recognized as the authority on horses, and his advice on horse matters was often sought by those wanting to make an equine purchase. An article of the day described his stables as "a model of beauty and convenience."

Winter's Café, located at 613 Walnut Street, was one of Madison's numerous neighborhood saloons where the workingman stopped for a schooner of beer after a long day at the packinghouse or glue factory. Albert Winter stands behind the bar in this 1890 photograph. Brass spittoons were placed strategically along the bar for the convenience of tobacco chewers. In the 1880s, Madison had at least 57 saloons, with 4 on Walnut Street.

Tobert Eaglin's Barber Shop at 316 Jefferson Street had all the chairs filled when this snapshot was taken in the early 1900s. Regular customers who came for a shave kept their own personal shaving mugs in the glass-front cabinet located at the rear of the shop. While there, customers could also have their shoes shined and hat and coat brushed.

Telephone service first came to Madison in 1878. By the early 1880s the Central Union Telephone Company exchange, shown here, was located on the third floor of 110 East Main Street above the Stanton Shoe Store. Julia Gavitt (right) was both manager and operator. The telephone operators overheard all the gossip and news and were often the best source of what was happening in Madison.

With the new popularity of the telephone, hundreds of wires had to be strung along Main Street. Telephone company workers paused from their work atop the telephone pole for this 1880s photograph, taken in front of the Gebest Hotel at 120 East Main Street. Until technology improved, customers shared the same party telephone line with others and could listen in on their conversations, a forerunner of today's conference call.

Louise Voiles (in the foreground) works with her assistants, creating new bonnets to be sold in her millinery shop at 103 West Main Street. Victorian-era fashions dictated that the proper lady always wore a hat, and Main Street in the early 1900s offered seven millinery shops from which she could choose.

Employees at the Snider Catsup Company paused from their work at the bottling machines for this 1920 photograph. Josephine Pavey Layton (far left) was one of the seasonal workers in the canning and bottling plant, which was located just south of the Madison railroad station. The plant fell victim to the 1937 flood, and traces of its foundations can be seen today from the J. F. D. Lanier Mansion Visitor Center parking lot.

The Eagle Cotton Mill, built on the riverfront in 1884, was one of Madison's major employers. Cotton shipped from the south by riverboat was processed and woven into large rolls of cloth. The weaving machines in this photograph were driven by steam-powered overhead pulleys connected by long leather belts. When the mill ceased operation, the vast building served for many years as a warehouse, and today it sits vacant.

The Madison Glue Company was located on Crooked Creek near St. Joseph's Cemetery. Processing by-products of the pork packing industry as well as dead horses, the factory produced glues used by furniture and saddletree manufacturers. When the factory went out of business, Madisonians regretted the lost jobs but not the foul odors and creek pollution associated with glue making, which permeated the neighborhood.

In this 1880s photograph, Ben Schroeder Saddletree Company workers display samples of their work. Schroeder crafted tens of thousands of wooden frames for saddle makers throughout the United States and Latin America. When the business closed in 1972, it was the nation's longest-lasting continually operated family-owned saddletree company. Restored with its original machinery and furnishings, it is now a museum operated by Historic Madison, Inc.

The Peter Beerck and Son Harness and Saddlery, located at 223–225 West Main Street, offered a full line of horse accessories. In addition to horse collars shown hanging from the ceiling, one could purchase saddles, harnesses, bits, buggy whips, blankets, robes, and even medicines. Advertised as "The Leading Store in Southern Indiana," the store sold many products made by Peter Beerck (left) and his son William.

In the summer of 1888, teamster Tom Clark arrives at the Johnson Starch Company on a dray loaded with new barrels for shipping cornstarch. Mule-powered two-wheel drays were a common sight around Madison, transferring goods between factories and delivering shipments coming in by railroad or steamboat. Barrels made locally were also used to ship beer, flour, tobacco, crackers, and other products made in Madison.

The Johnson Starch Company was built in the early 1870s by prominent businessman Richard Johnson, an Irish immigrant, and was managed by his son John. Richard Johnson was also president of the Eagle Cotton Mill in Madison. The Gloss Starch made by Johnson was a popular laundry favorite for starching shirts and dresses, and the packages shown here were a common sight on grocery store shelves throughout the eastern United States.

The Johnson Starch Company, located on the riverfront, was the subject of this painting by Madison artist William McKendree Snyder. Another painting by Snyder, who specialized in landscapes of southern Indiana, was one he painted for "Doodles" Coyle, owner of Coyle's Tavern. Snyder, quite a drinker, paid Doodles by painting a rather risqué picture that hung over the back bar of the tavern for years.

In this 1920s photograph, William McKendree Snyder works in his cluttered studio at 127 East Street, where he lived until his death in 1930. Snyder often went out on location accompanied by photographer G. L. Spaulding, who took photographs of the scenes to help Snyder fill in the details of his paintings. Spaulding also bought unframed canvases from Snyder when the artist needed money. Snyder's works, some of which hang at the County Historical Society, are highly valued today.

The Central Hotel, located at Mulberry and Second Streets, looks much the same today as it did in the 1920s when this postcard was printed. In the late 1800s, the hotel was owned by Sam Herin, who also owned two nearby stables. This busy block of Mulberry Street was well known for its many taverns and rowdy nightlife, which attracted crewmen and travelers from the riverboats.

The lobby of the Central Hotel in this 1915 photograph was typical of the hotels in town, with an embossed tin ceiling and a coal-burning heat stove for guests to gather around. A sign over the door marks the entrance to a separate ladies' waiting room, and a poster advertises the Elk's Club Minstrel Show appearing at the Grand Opera House on Main Street.

Paul Meyers was the 23rd owner of the old oil delivery wagon in this 1927 photograph. The chalkboard on the wagon shows that the price of coal oil was 19¢ and gasoline 20.3¢ per gallon, delivered to the home. In the late 1800s and early 1900s, coal oil (kerosene) was very much in demand for both lamps and heating, as well as a deterrent for chiggers.

There was no clinking of bottles when this milkman made his delivery. Until the invention of the milk bottle in the 1880s, home delivery of fresh milk involved its transfer from large milk cans to containers provided by the customer. J. D. Duffy, standing by his horse and wagon in this photograph, operated one of the many small farm dairies that served Madison in the 1800s.

The Johann Grocery Store at Walnut and Fifth Streets in the Georgetown neighborhood was one of many small grocery stores in Madison. In this 1914 photograph are four members of the Johann family—William, Molly, Nell, and Russell. Later owned by the four Breitenbach sisters, the grocery often sold a ton and a half of turkeys each Thanksgiving and Christmas season. The building is now a liquor store. (Courtesy Historic Madison, Inc.)

As a county seat, Madison had many lawyers. Marcus Sulzer, who twice served as the mayor of Madison, sits at his rolltop desk at the Sulzer and Bear Law Office. He was the city attorney and prosecuting attorney, and he served as postmaster. He owned Sulzer Brothers Drug Company, which sold roots, herbs, barks, and seeds throughout the world, and was described as "one of the city's most brilliant and reliable citizens."

Drayman John Louis Spicer, in this 1899 photograph, sits atop a wagon filled with paint. According to the sign on the railroad car, they are destined for the Rogers Drug Store at Main and West Streets. House paint, glass, and hardware were commonly sold at Madison drugstores in the early 1900s.

When the old market house closed in the early 1900s, farmers began selling their products at a weekly outdoor farmer's market on the sidewalks around the courthouse. In this 1936 photograph, Jefferson Street is crowded with women shopping as the men hang out, perhaps swapping stories and discussing the weather. The farmer's market tradition still continues each summer in Madison, offering fresh produce from local farms.

The Pearl Packing Company was located on West Street along Crooked Creek (now the site of Pearl Park). August "Gus" Yunker founded the business in 1894, and it later expanded into a major Madison company with 115 employees. Yunker completed his next-door residence (left in photograph) in 1900. It later served as the company's office. The company folded in 1974, and all but one of the buildings were demolished. (Courtesy Louis DeCar.)

Fresh pork bellies from Pearl Packing Company are loaded onto express cars at the Madison railroad station on First Street for quick shipment to butcher shops in Indianapolis. In addition to pork processing, the company was known for its high-quality cooking lard and for its hams, which were marketed by mail order and in stores throughout the Midwest.

In 1903, Pearl Packing Company added an ice-making plant and was soon supplying Madison with blocks of ice for cooling home iceboxes. In this 1935 photograph, Cutter Robinson and Charlie Hollis make a delivery near St. Michael's Church. Customers would leave a card in their front window, telling the iceman how much to deliver each day. Ice was also produced and sold by the breweries in Madison.

A butcher carves a side of beef hanging on the wall of the City Meat Market at 117 East Main Street. Yunker came to Madison as a butcher in 1875 and 13 years later purchased this building, which still shows the "Gus Yunker" name embedded in the nearby sidewalk. Cattle and hogs slaughtered at Yunker's Pearl Packing Plant were sold at the butcher shop the very next day.

William C. Heberhart (right) stands outside his drugstore at 835 West Main Street. Parked at the curb in this 1880s photograph is Heberhart's high-wheel bicycle. A cycling enthusiast, he was an organizer of the Madison Bicycle and Athletic Club, which sponsored bicycle excursions around the county. Not surprisingly, a bicycle shop was located next door to the drugstore. Heberhart was also an excellent amateur photographer and through his store sold prints of many historic Madison scenes, some of which appear in this book. Located at the west end of Madison's Commercial District, the Perry and Dunbar Drug Store is in the same building today, and customers can still enjoy an ice-cream sundae at the store's vintage soda fountain. The business was recently honored by the State of Indiana as a drugstore operating continuously in the same location for over 150 years. (Courtesy Kenneth Dunbar.)

Four
HAVING A GOOD TIME

Jacob Glass, who was killed in the Civil War, established the Glass Confectionery in 1845. At the time of this 1880s photograph, it was operated by Frederick Glass, who produced the very first "Little Fish Mixed Candy" in a dozen flavors and colors. The fish candies were later crafted by Mundt's Confectionery and are still made today. The Glass Confectionery, located at 126 East Main Street, made its own ice cream and was a popular place to take the family for a treat. It later moved to Mulberry Street and then evolved into the Glass Dairy Company. (Courtesy Robert Glass.)

The Beech Grove Driving Park was located at the far west end of Madison near the river. A popular summer attraction, the park featured a racetrack, horse barns, a baseball diamond located in the track's infield, and picnic groves among the beech trees. Before the racetrack was created in 1875, it was the site of county fairs and meetings, including the third Indiana state fair in October 1854.

Club members gather on the lawn of the Madison Country Club for a holiday celebration. Built as the Hunter Mansion in 1842, this building became the clubhouse when the country club was formed in 1913. A golf course was constructed on the old racetrack site and on adjoining land leased from the Chautauqua Association. The country club also offered tennis and horseshoes. Today a restaurant uses the former clubhouse.

Members of the Madison Bicycle and Athletic Club, while on an outing, stop for this 1890s photograph taken on the Eagle Hollow Iron Bridge, located east of Madison near the Ohio River. The once popular high-wheel bicycles, also known as "penny-farthings," were losing favor to the new, smaller, chain-driven models. The bicycle leaning on the bridge belongs to drugstore owner William Heberhart, who took this photograph.

On a picnic at Cedar Cliff, Lida Hutchings and friends view the Ohio River with their telescope. Lida (sitting far left) was an avid amateur photographer and took this 1892 photograph with a squeeze bulb and tube connected to the camera. Also sitting are (left to right) Jennie Stringfellow, Mary Hampton, a Miss Cochran, and Zoe Hutchings; standing are (left to right) Ella Hampton, a Mr. Ketchem, a Mrs. Bowman, and Maude Hutchings. (Courtesy Historic Madison, Inc.)

The Minstrels Parade on Main Street heralds the annual arrival of the circus to Madison. This 1892 photograph looks west as the lion's wagon, with the circus musicians sitting on top, approaches West Street. Children, eager to see a live lion, run alongside the wagon for a closer view. During the late 1800s and early 1900s, many circuses—both small and large—traveled through the Midwest. (Courtesy Historic Madison, Inc.)

When the Tom Mix Circus and Wild West Show came to Madison during their 1936 tour, they set up the big top in a large field in Irish Hollow located west across state Route 7 from Springdale Cemetery. Tom Mix, who was a former silent movie cowboy star, owned the circus and starred in the show. The circus traveled from town to town in a caravan of trucks instead of horse-drawn wagons.

Anna Danner provides some winter fun for the neighborhood children by pulling their sleds up snow-packed West Street. She is trying out a brand new Overland sedan from the dealership owned by her husband, Ray Danner. The dealership garage (in background) was once a livery stable but was razed in 1981 and today is a parking lot for the Madison Courier.

Having a good time in the winter of 1927 are children from the east end of Madison who found a good sledding hill at the head of Baltimore Street where it meets Telegraph Hill.

Gayoso's was one of the old-time saloons in Madison, most of which had one attribute in common: they were a man's world, a "poor man's club," and women were not welcome. The bartender not only served the beer but also listened to the customers' sad stories, settled disputes, and handed out advice when needed. Good Irish or German food was often served, which would be washed down with schooners of cold beer.

The ladies of the church guild gathered under the shade of a tree on the lawn of the Christ Episcopal Church for this c. 1910 photograph. From the display of fancy millinery, perhaps they are showing off their Easter bonnets. Church activities were a vital part of Madison's social life, with suppers, outings, musical events, and other activities organized by the women of the churches.

The first organized Madison motorboat races were held in 1914 when the steamboat *Princess* was anchored in the middle of the Ohio River, and gasoline-powered launches raced an oval course around the steamer at a breakneck speed of 20 miles per hour. Crowds watched from the riverbank and from dozens of nearby boats. The races continued each year, and it became known as the Madison Regatta.

Crowds gather on the riverbank between Poplar and Central Streets to watch the Madison Regatta on July 4, 1930. Behind them, the McKibben-Maddox tobacco warehouse has been decked out with banners for the event. Temporarily halted during World War II, the regatta resumed in 1948 and continues to be a major Madison event, drawing crowds of up to 100,000 spectators. The speed of today's hydroplanes can exceed 200 mph.

People flocked to Chautauqua, which brought to small-town America performance arts, intellectual ideas, well-known personalities, and lively debate of regional and national issues during the late 1800s and early 1900s. This 1915 postcard shows a view of the auditorium at the Madison Chautauqua meeting, which was held each summer from 1901 to 1929 on the grounds of the old Beech Grove Driving Park.

Pictured here from left to right are Anna Lowery, Patrick Lowery, and Josephine Cadzan at their well-furnished rented tent in the campground at the Madison Chautauqua meeting. On July 6, 1901, the Honorable William Jennings Bryan addressed thousands of people at the Madison Chautauqua. Other notables that spoke here were Billy Sunday and Booker T. Washington. The Madison Chautauqua invited everybody to an "intellectual feast of rare artistic merit."

In 1851, circus promoter P. T. Barnum embarked on a nationwide tour with a Swedish opera singer that would bring him a vast fortune and create a new cultural phenomenon: the celebrity. Jenny Lind, "the Swedish Nightingale," came to Madison, and her concert was given in the town's largest building—a pork slaughterhouse that was cleaned out and whitewashed for the occasion.

In 1909, Madison celebrated its 100th year with a centennial celebration that had a carnival atmosphere. There were speeches, food booths, a freak show, an Edison "moving picture," souvenir stands, and of course a parade. In this photograph, looking west on Main Street from the corner of Jefferson, the buildings are decked out with flags and bunting and the crowds have gathered for the start of the parade.

There was excitement on Main Street when Buffalo Bill's Wild West Show rolled into Madison. In this 1890s photograph, the crowd in the 100 block of West Main Street watches as a stagecoach passes by the B. F. Calloway Wallpaper Store on its way to Beech Grove Park, where the show was held. Wild West shows fascinated audiences with buffaloes, bears, bucking broncos, Conestoga wagons, real cowboys, and Native Americans.

The 1916 Fall Festival Parade gave these ladies riding in a crepe paper–decorated Ford Model T a chance to show off their latest millinery creations. More than 100 decorated automobiles paraded on Main Street, hoping to win a prize. The festival (and county fair) was held in downtown Madison and featured automobile obstacle course races, high-wire acts, and industrial exhibits, as well as traditional county fair attractions.

Hikes and walks were popular pastimes in the early 1900s, and the scenic railroad incline was a popular destination for hikers of all ages. In 1853, Henry Ward Beecher, who at the time lived in Indianapolis, came to Madison to preach and rode a handcar down the incline into town. He described the experience as the "fastest ride" of his life.

Musical groups in Madison varied from the "oomp paa paa" of the Haymakers Band to the classical sounds of the Madison Philharmonic Society Orchestra pictured in this 1887 photograph. Among the orchestra musicians were photographer Joseph Gorgas (back row, third from left), drugstore owner William Rogers (first row, third from left), and undertaker Frank Vail (first row, fifth from left).

On this postcard showing the Elks Club (left) on West Street, a lady wrote, "Where they all hang out." The *Madison Courier* reported that on June 11, 1910, "the sheriff and police searched the Elk's Club, removing 14 barrels of beer and nine quarts of whiskey. Help was needed to roll out the beer and take it next door to the City Hall." It was later quietly returned.

The Haymakers Band was one of the most popular in Madison, appearing in parades, at the Chautauqua, and in concerts. The Haymakers was a somewhat secretive American fraternal order whose meetings were held in places called haylofts and whose officers bore titles like collector of straws (secretary) and guard of the barn door. In reality, their main objective seemed to be fellowship and having a good time.

Etta and Nell Hoffstadt are the two young girls out for a pony-cart ride on Main Street in this late-1890s photograph. Watching over them on their ride is Edith Johnson. Pony rides, a popular amusement for children, were often provided for a small fee by itinerant operators who visited the neighborhoods, offering rides in carts or on the pony itself.

The Cincinnati Reds paused for this 1912 photograph as they arrived at their hotel in the new motor hack driven by John Collins. They came to Madison by river packet to play an exhibition game with a local team. Among the Reds who came was Smiling Bob Bescher, who in 1912 led the league in runs scored. More than 2,000 people came to John Paul Park to see them play.

This 1910 postcard shows the fountain and gardens of John Paul Park, which was established in the early 1900s through the efforts of the local Daughters of the American Revolution chapter. Named after Col. John Paul, one of the founders of Madison, the park was previously an early Madison cemetery. The graves were moved to Springdale Cemetery, and the park was landscaped with trees donated from the original 13 colonies. (Courtesy Kenneth McLain.)

John Paul Park, located on West Third Street was a popular place for children's activities. The boy's baseball team from nearby Lower Seminary School poses for this 1912 postcard, while the girls play at the fountain in the background. Although the fountain is gone, the park today is still a place of peaceful enjoyment. (Courtesy Kenneth McLain.)

Before it became John Paul Park, the old cemetery was a good place for winter fun. At the west end, the steep slope down to Crooked Creek made an ideal sledding hill. Trying their toboggan in this 1893 photograph are, from left to right, W. T. Reiser, John Lewis, W. H. Todd, Robert White, Joseph DeLoste, Pres Lewis, Lewis Scheik, George Cowlam, and Harry Vail.

Oops! The merry group of young men takes a fall before they even start down the hill.

The Crystal Beach Pool, a Depression-era Works Progress Administration work project, was opened in 1939. Built on the site of the old Trow flour mill, the pool house was constructed using stones salvaged from the mill foundations. In this 1944 photograph, a film crew atop a platform shoots a scene for *The Town*, a World War II propaganda film depicting Madison as the typical American town.

Four bathing beauties enjoy the "beach" at poolside. The new pool was surrounded by 12,000 square feet of beach sand. In March 1939, Ella Van Tyle won $25 in the contest to name the new 800,000-gallon swimming pool, which cost $100,000 to build. The winning name, Crystal Beach, is still used today, although the sand beach was later removed due to maintenance difficulties. The pool has been damaged in several floods but was repaired and remains open today.

Five
Indiana's Pioneer Railroad

The Madison Railroad Station was a lively place when the morning train from Indianapolis arrived. In this early-1900s photograph, horse-drawn omnibuses and buggies wait to take arriving passengers to downtown hotels and businesses. Built in 1895 by the Pennsylvania Railroad, the brick station featured a two-story octagonal waiting room. It is now a railroad museum owned by the Jefferson County Historical Society.

Completed in 1841 as part of the Madison and Indianapolis Railroad, the famous Madison Incline took more than five years to build. Over a mile in length, the incline climbs at a steep 5.9 percent grade from the riverfront through two deep rock cuts to the hilltop. Visible at the bottom of this 1880s view is a city water reservoir, and near the top is Hanging Rock Road.

The scene of a train with its special hill locomotive thundering down the incline provided a very popular tourist postcard subject in the early 1900s. The incline has not been used since the early 1990s. Although abandoned, it can be viewed today from the bridge on Main Street, where a historic marker commemorates its significance in railroading history.

In the first years of operation, cars had to be hauled up the incline with horse teams. The invention of a cog-assisted locomotive enabled trains to climb the incline under steam power. The cog locomotive *John Brough*, shown here in a rare 1850s daguerreotype photograph, featured a new canopy to protect the engineer, who previously was exposed to the elements. It was named after the president of the Madison and Indianapolis Railroad.

This 1868 builder's photograph shows the new locomotive *Reuben Wells* at the Jeffersonville Indiana shops. Designed for use only on the incline, it had 10 driving wheels for maximum traction. Its tender and water tanks were incorporated into the engine, putting additional weight over the driving wheels. The cog system, no longer needed, was removed from the incline. The locomotive is now on exhibit at the Children's Museum of Indianapolis.

At the railroad yards in North Madison, trains coming up the incline from Madison would stop for a change of locomotives. The hill locomotive (right), which brought the train up the incline, was uncoupled and replaced by a road locomotive for the trip north to Indianapolis. Visible in this 1880s photograph is the 21-stall roundhouse with an indoor turntable. It was demolished in 1906.

The North Madison depot was completed in 1910 at a cost of $9,000. Designed to be compatible with the architecture of nearby Madison State Hospital, it was a brick building of exceptional detail and beauty not often seen in a small town railroad station. Passenger service stopped in 1936, and it became a freight terminal. Later abandoned by the Pennsylvania Railroad, it was demolished in 1968.

The 1849 Madison passenger depot was located adjacent to the freight depot on Vine Street near the riverfront. The brick depot building was 270 feet long with the track entering from the west end, allowing trains to pull inside the building for loading of passengers. In its cupola was a bell that was rung to signal when the train was about to depart.

In this 1949 photograph, a freight train passes the J. F. D. Lanier Mansion heading west along the river toward the incline. To the left, Pearl Packing Company refrigerator cars are stored on a siding where the old freight depot once stood at Vine Street and Vaughn Drive. The old tracks are still in place along some parts of the riverfront, visible at the western end of Vaughn Drive.

A real-photo postcard captured the departure of the final run from the Madison station when passenger service was permanently halted on June 30, 1931. Standing next to the locomotive is engineer John Pogue. Limited passenger service from the hilltop North Madison station to Columbus, Indiana, continued for several years after this, using an Interurban-type gas-electric car, but that also was discontinued in 1936.

After passenger service stopped, the station was used as a Depression-era community center until 1937 when the Pennsylvania Railroad converted it to a freight terminal to replace the flood-damaged riverfront facility. The interior was gutted, the south portico removed, floors raised, and a loading dock added. When the Jefferson County Historical Society acquired and restored the station, all of these alterations had to be reversed.

Six
GOING TO WAR

LT. COLONELS FROM MADISON KILLED IN ACTION IN THE CIVIL WAR

Lt. Col. Jacob Glass

Lt. Col. John Hendricks

Lt. Col. Alois Bachman

Lt. Col. John Gerber

Lt. Col. Philemon Baldwin

It was a rare coincidence of the Civil War that these five lieutenant colonels were all from Madison and that they all died valiantly in battle. John Hendricks, son of Indiana governor William Hendricks and Ann Hendricks, daughter of Madison founder John Paul, was killed on his 39th birthday at the Battle of Pea Ridge, Arkansas. Philemon P. Baldwin operated a farm implement business in Madison. He was killed leading his troops in the Battle of Chickamauga. Alois Bachman was killed leading his men in a charge at the Battle of Antietam. The Madison post of the Grand Army of the Republic was named after him. Jacob Glass came to Madison from Germany in 1857 and opened the Glass Confectionery. He died of wounds he received in the attack on Missionary Ridge in Georgia. John Gerber, a native of Germany, came to Madison in 1837 and worked as a butcher and also served as town marshall. He was killed at the Battle of Shiloh in Tennessee.

Madison General Hospital was a temporary Civil War military hospital operated by the U.S. Army. Located near the riverfront at the present site of a golf course, the hospital was a complex of 72 buildings, one of which is shown in this rare 1863 photograph. One of the largest in the United States, it treated over 8,000 sick and injured soldiers before closing in 1865.

Pictured above, the Baxter family members were prosperous abolitionists from Scotland. During the Civil War, all seven sons served in the Union Army and survived, living well into their 70s and 80s. This photograph, which was taken in 1911, shows the entire family, but look closely: the man third from the right, Oliver Hazard Perry Baxter, had died the year before and his "ghostly" photograph was inserted into the picture.

Called a "Splendid Little War," the Spanish-American War of 1898 attracted a number of volunteers from Madison. Joseph L. Rogers (center) posed for this studio photograph after his return from service in Cuba. In an interesting connection, numerous companies in Madison made saddletrees (the frames on which saddles are built) for military saddles used in the Civil War, Spanish-American War, and World War I.

With the outbreak of World War I in 1917, patriotic Madisonians who were not subject to the draft formed Company K, a volunteer state militia company, to serve their country as a "home guard." In this 1918 parade photograph, the company, led by Capt. Frank Pritchard, marches west on Main Street past West Street.

U.S. Army captain Samuel Woodfill, a Jefferson County farm boy, is shown in this publicity photograph wearing the medals awarded him during World War I. Woodfill was honored for heroism in the Meuse-Argonne offensive near Cunel, France, where he single-handedly killed at least 26 Germans and destroyed their Boche gun emplacements. Woodfill received the Congressional Medal of Honor, the highest military honor, as well as 14 other decorations or medals. After the war, he embarked on a national publicity tour, appearing with Pres. Calvin Coolidge and many other notables. He returned home to a quiet life and occasionally lived with his brother Bill at 801 Walnut Street in Madison.

A group of spectators watches as World War I artillery practice takes place in Madison on the riverfront. The sounds of war echoed across the Ohio River as the state militia companies practiced firing artillery guns using blank charges. Madison served the war effort in many other ways, including Red Cross work, Liberty Loan fund drives, and other community activities.

A somber group of World War I draftees, wearing their temporary identification tags, stands in front of the railroad station for this photograph, taken by Madison photographer Louis Cohen. Madison was the point of departure to training camp for draftees of several nearby counties, and Cohen photographed each group, creating a pictorial record of more than 50 photographs now preserved in the Jefferson County Historical Society photograph collection.

During World War II, there was excitement on Main Street when, in 1943, this captured Japanese submarine was put on display in front of the courthouse. Large crowds came to view the craft, mounted on a special flatbed truck, which rolled into Madison on a government-sponsored tour across the country.

World War II bond drives were a critical part of financing the war effort, and Jefferson County alone raised over $8 million by the war's end. In this 1942 photograph taken at Main and Mulberry Streets, Madison Girl Scouts gather around the sidewalk booth where they sell war bonds. Dorothy Inglis Reindollar (top row, third from left) later became an important civic figure in Madison. (Courtesy Dr. Marcella Modisett.)

Seven
CHURCHES AND SCHOOLS

The Broadway Second Baptist Church congregation gathers in front of the church at 615 Broadway for this early-1900s photograph. The church was organized as early as the 1830s by businessman John Carter and Underground Railroad activist Chapman Harris. After meeting in several other Madison locations, they completed this building in 1883. It is still active today. (Courtesy Sue Livers.)

Christ Episcopal Church, founded in 1835, began construction of this church building at Mulberry and Third Streets in 1848. It was one of the first examples of English Gothic Revival to be found in the Old Northwest Territory. Emilie Todd Helm, half-sister of Mary Todd Lincoln, came from Elizabethtown, Kentucky, to live in Madison and was said to be the organist at Christ Episcopal Church.

The sanctuary of Christ Episcopal Church was decorated for Thanksgiving when this photograph was taken in 1886. The church is renowned for its beautiful windows, which have been recently restored to their original brilliance. The three east windows over the altar are considered to be outstanding examples of early American stained glass and were installed in 1850, years before Louis Tiffany began designing his stained-glass windows and lamps.

The Trinity Methodist Episcopal Church, located on Broadway just north of Main Street, was completed in 1873. Its ornate spires towering over the nearby Broadway Fountain have made it the subject of artists and photographers for generations. Next to the church in this 1880s photograph is the stately residence of Nathan Powell, a prominent Madison businessman. The residence was converted to a funeral home in 1937.

Founded in 1807 by Jesse Vawter, the First Baptist Church of Madison was the first church in Jefferson County. Originally located on the hilltop, the congregation moved to 416 Vine Street in 1831. The cornerstone of the Greek Revival church building pictured in this 1910 postcard was laid on June 9, 1853, and took seven years to complete. In 1901, a new tracker pipe organ with 756 pipes was installed.

St. Mary's Catholic Church, located at 415 East Second Street, was completed in 1851, and its steeple was added in 1860. It was founded when many of the German-speaking Catholics attending St. Michael's Church, who had trouble understanding the Irish priest, decided to establish their own parish. The Catholic school building (left in the photograph) was built in 1876 and was used until 1966. It was razed in 1982.

This interior view of St. Mary's Catholic Church appeared on a 1915 postcard. Its beautifully detailed decoration was reminiscent of European churches, in which the immigrants had worshiped. The interior has since been repainted in a simpler style. In 1993, St. Mary's was combined with St. Michael's church and the other Catholic churches of Jefferson County and was renamed Prince of Peace Parish. (Courtesy Kenneth McLain.)

St. Michael the Archangel Church, founded in 1837, was said to be designed by Madison architect and church member Francis Costigan. It welcomed immigrants, particularly of Irish descent, who came to Madison to build the Madison and Indianapolis Railroad. Stone from the railroad incline cuts was used to construct the Gothic-style edifice located at 519 East Third Street. No longer active as a church, the building is owned by Historic Madison, Inc.

First Presbyterian Church, formed in 1815, was the third church established in Madison. This church was built at Broadway and First Street in 1846 at a cost of $15,000. During construction, the bell from the unusual octagon-shaped, copper-roofed cupola fell and crashed into the basement. Early church members included many notable Madison citizens such as the town's first mayor, Moody Park.

Congregation Adath Israel was organized in 1853 and held its first service in an upstairs room over the Lotz Shoe Store at 216 Main Street. In 1868, the congregation purchased this building at 115 East Third Street to use as their synagogue. Built in 1838 as the old Radical (Methodist) Church, it is today a private residence. Until the late 1920s, Madison had a large and influential Jewish population.

It is now known as St. John's United Church of Christ, but when this c. 1915 congregation photograph was taken, the church, located at the corner of Main and East Streets, was St. John's Lutheran Church. The church was originally the home of the German Evangelical Lutheran and Reformed Church of Madison and was built in 1850. Until 1916, all services were conducted and records kept in the German language.

The West Madison Methodist (now United Methodist) Church at 1092 West Main Street was constructed in 1893 when West Madison was a separate town. When the town was annexed in 1906, Madison required new concrete sidewalks, and the church raised money to install sidewalks along the church property. Church members who donated money had their names imprinted in the concrete squares, many of which are still visible today. This photograph was taken in 1927.

The John T. Windle Memorial Auditorium, located at the corner of Third and West Streets, is one of the most notable examples of Greek Revival–style architecture in the Midwest. The building was constructed in 1835 as the Second Presbyterian Church. In the early 1840s, Henry Ward Beecher, a noted abolitionist, preached at the church. Historic Madison, Inc., acquired the property in 1961, and the lower level now serves as their headquarters.

This two-story brick Italianate building was constructed in 1877 on the northeast corner of Second and Central Streets as the new Madison High School, replacing the old building located just kitty-corner on Second Street. In 1907, due to overcrowding, the high school moved back across the street, and it served as a grammar school and junior high school until 1928. It was later destroyed by fire and demolished.

The 1896 senior class gathers on the steps of the Madison High School for this class photograph. According to newspaper accounts, Madison High School had mandolin and guitar clubs and an Orpheus club of singers in the 1890s. There was also an oratorical association, which competed statewide. The young man in the top row seems more interested in the young lady than in having his picture taken.

In this 1910 snapshot, members of the Madison High School "Middies" basketball team gather with their coach among the flowering bushes in front of the Shrewsbury House. Their modest basketball uniforms reflect the conservative styles of the early 1900s. Bernice Knoebel Friedersdorf (far right, second row) is the only person identified.

This was the first Madison High School football team, organized in 1896 by a newly formed high school athletic association. The school yearbook stated, "The team's linemen were outclassed in weight by almost every opponent, but their playing was of the stone wall and bulldog variety." Michael Garber (top row, far right) later became publisher of the *Madison Courier*.

Lawn tennis became a popular women's sport in the Victorian era, particularly at the country club. In this 1895 photograph of the Madison High School Tennis Club, in no particular order, are Inez Long, Fannie Schiek, Annie Cravens, Mabel Burke, Suza Brinkworth, Mattie Little, Mabel Taylor, Mayme Glass, Florence Glaser, Lottie White, Allie Waymond, Rebecca Drake, Bertha King, and Nellie Thomas.

Madison High School occupied this building, located on the southwest corner of Second and Central Streets, from 1868 to 1877 and from 1907 to 1928. Built as a hotel in the 1850s, it was expanded in 1868 for use as a school. In its last days, it served as an American Legion post but was destroyed by fire in 1977. Today the site is a private park.

The Broadway School was located at 627 Broadway. Built in 1880 as a grammar school for the African American community of Madison, it was expanded in 1898 to include high school students. It was built from the same plans as the old city hall on West Street. It closed in 1958 with the integration of the Madison schools and became a community center but was destroyed by fire in 1969.

The Broadway School faculty members gather on the front steps of the school for this c. 1910 photograph. The teachers and their classes were Eva Williamson—first and second grades; Irene Wilson—third and fourth grades; Pauline Batties—fifth, sixth, and seventh grades; and William Lowndes—eighth grade and high school. Albert Bailey, principal, is second from right in the photograph. Today the site of the school is a small community park.

The "new" Madison High School on the southwest corner of Broadway and First Street was completed in 1928, replacing an old mansion that stood on the site. The building survived the waters of the 1937 flood and served until 1960 when a new facility was completed on the hilltop. After years of vacancy, it was recently refurbished and transformed into an attractive senior citizens' apartment complex.

Lower Seminary School, located at 714 West Main Street, was demolished in 1923, shortly after this photograph was taken, and replaced by the Middleton School. The center portion of the school was built in the early 1840s as a tuition academy. It became a city school, and wings were added in the 1870s. Its bell survived the demolition and is now displayed in the park at Third and West Streets.

Fulton School, built in 1876 to serve the far eastern portion of Madison, was located at Ferry and Park Streets. It existed as a school for only 31 years and closed its doors on October 3, 1907, when its students paraded ceremoniously to the new Eggleston School. It later became a residence and today is a church building.

Miss Muse, a teacher, watches her students play in front of the Walnut School in this 1890s photograph. Built in 1864 at 937 Walnut Street, the school was also known as Georgetown School, as it served the Georgetown neighborhood. Located near Crooked Creek, it suffered flood damage when the creek overflowed. It closed with the completion of Eggleston School and sat vacant until the late 1940s when it was demolished.

Eggleston School, seen in this 1911 photograph, opened in October 1907 with speeches by city officials and music by the Haymakers Band. It was built on the site of the old Upper Seminary School at 415 East Street, where it exists today. School education was very important in Madison almost from the day the city was founded. Early Madison offered a number of private schools, including a young ladies' seminary.

Eggleston School was named for Dr. Edward Eggleston, author of *The Hoosier Schoolmaster*, published in 1871. The popular book recounted the experiences of a new teacher at a country school in southeastern Indiana. Eggleston, who at one time lived in Madison, was also the author of several other books including *The Circuit Rider*, for which the author drew on his own experiences as a traveling minister in southeast Indiana.

Eight
SERVING THE COMMUNITY

Since the 1840s, Madison has been served by volunteer fire companies, a tradition that continues today. The Walnut Street Fire Company No. 4 firehouse, pictured in this 1898 photograph, was built in 1874. The building at 808 Walnut Street was used until 1960. Early "Fours" members were called the Wooden Shoes, as many of them were Germans who wore wood shoes at their packinghouse jobs and to fires.

Western Fire Company No. 3, pictured in this 1905 photograph, was organized in 1850 with 79 "efficient members" and an engine, reel, and 600 feet of hose borrowed from the Washington and Fair Play Companies. The firehouse was located at 712 West Main Street on a corner of the Lower Seminary School yard. In 1926, they moved to their present location on Main Street. Their motto is We Conquer to Save.

The Washington Fire Company No. 2 firehouse was erected in 1848 at Third and West Streets. Still used, it is the oldest firehouse in continuous use in Indiana. Anna Barton Powell, the young girl in this 1880s photograph, was visiting across the street and while playing outside was invited by the firemen to get in the picture with them. Their motto was For the Public Good, We Hazard Our All.

The Fair Play Fire Company No. 1 has the distinction of being Madison's first fire company and also Indiana's oldest volunteer fire company. Their firehouse at 407 East Main Street, built in 1888, is still in use. Atop the 55-foot bell tower (not visible in this 1890s photograph) is a distinctive copper weather vane known as "Little Jimmy." The motto over the firehouse door is Help One Another.

It was a test of new versus old when the new Fair Play Company No. 1 Aherns fire truck arrived to replace the old horse-drawn, steam-powered engine. In this 1919 photograph, the two are pumping water from one of the numerous cisterns that was built under Main Street to store water for firefighting. The cisterns were made obsolete when hydrants were installed throughout the city.

The Madison Post Office, completed in 1897, was located on the southwest corner of West and Third Streets. Once described as the most beautiful building in the state, it was constructed of Colorado red stone and highlighted with Bedford stone. The Victorian-styled interior was finished in oak. Sadly the masterfully designed building was demolished in 1963. On the site today is a parking lot and small park.

Rural free delivery of the U.S. mail first came to southern Indiana around 1900. Until then, rural residents had to travel to Madison to pick up their letters. In this 1905 photograph, mail carrier Charles Hoefling, who worked out of the Madison Post Office, is making his daily delivery stop at the home of Dr. John Matthews.

The stately residence on the northeast corner of Main and Elm Streets in 1930 became the home of the Madison-Jefferson County Public Library. It was built in the early 1900s for Madison businessman Edward Powell. The library made minor changes in 1934, and a major addition was constructed in 1967 to the front and side, giving it the modern appearance seen today.

The Brown Gymnasium (right in photograph) has served Madison as a community sports center since its completion in 1925. Located on Broadway just north of the riverfront, its construction was funded by philanthropist J. Graham Brown, a Madison native. When the Madison High School replaced the home next door, it served as the school gymnasium. Renovation from the 1937 flood included adding the new front seen today.

Denny's Private Sanitarium, a hospital operated by Dr. George Denny, was located at Fourth and Jefferson Streets. A 1907 flyer for the sanitarium, which accommodated 10 patients, advertises that it provided equipment for surgery, treatments for the diseases of women, x-rays, and hot air treatment, all at reasonable prices. Denny was a member of the school board, commanded a local U.S. National Guard medical detachment, and was owner of the Hillside Hotel.

In 1896, a small band of women formed the Bethany Circle of the King's Daughters to assist the poor and those in need. Soon their goals expanded to establishing a real hospital to serve the community. Mrs. Drusilla Cravens, a well-known philanthropist, purchased this home at 112 West Presbyterian Avenue and donated it as the building for the first King's Daughters' Hospital.

In 1915, ground was broken for a new King's Daughters' Hospital building to replace the inadequate, old, converted residence. The new building, pictured in this 1927 photograph, has expanded and grown over the years to a state-of-the-art regional medical center covering several blocks. Today the hospital is one of the biggest employers in the county.

Today emergency medical transportation is provided by the hospital, but in the 1920s, when this photograph was taken, Madison relied on funeral homes for ambulance service. Funeral director Sidney Haigh is at the wheel of the Haigh Funeral Home ambulance, parked in front of the King's Daughters' Hospital. On the running board is a "lungmotor," the latest resuscitator machine.

Howard Demaree was the first Indiana State Police trooper to be assigned in Madison. In this later 1920s snapshot, he stands next to his Hupmobile Speedster, parked on Jefferson Street near Third Street. Improvements in roads around Madison and the growing popularity of automobiles increased the need for highway traffic enforcement.

The entire Madison Police force gathered next to the new Hudson Terraplane patrol car for this 1935 photograph taken in front of the old city hall at 416 West Street. With frequent Depression-era bank robberies, the officers kept several shotguns handy. Pictured are (from left to right) Chief Oliver Eaglin and patrolmen Elmer Hanlin, Bill Gray, Reed Hanna, and Albert Sauley. (Courtesy Marilyn Imel.)

Nine
GETTING AROUND

Manley Wilson (far right) takes his family for a ride around Madison in their new touring car. The noisy, expensive automobile was still a novelty. In this early-1900s photograph, Wilson's young son helps the chauffeur steer around the potholes in the unpaved street. Wilson was a prominent lawyer in Madison, a member of the city council, and the city attorney.

Young Lloyd Crutchlow gets around town quickly in his Roaring 20s runabout speedster. From it, parked in the middle of Main Street across from the courthouse, he smiles for this 1925 photograph taken by Harry Lemen. A realtor by profession, Lemen was an avid amateur photographer whose collection of some 4,000 photographs documented Madison and its people in the 1920s and 1930s.

This 1920s Detroit Electric was the only electric automobile in Madison. This photograph shows it parked in front of the Smith home at 612 West Main Street (formerly the Peter Weber residence). It was driven around town by Henrietta Smith. Popular with ladies and doctors, the electric automobile was powered by storage batteries and was easily started. Unfortunately it was slow and only went 80 miles between battery charges.

Hillside Hotel patrons were offered free transportation to and from the railroad station and riverfront via this jitney bus operated by the Hillside Hotel. A similar bus operated by John Collins served the other hotels in Madison and also served the Clifty Inn at nearby Clifty Falls State Park.

The Southland Transportation Company intercity bus in this 1927 photograph is parked on Second Street alongside the Central Hotel terminal, loading passengers for a trip to Cincinnati. Southland also provided bus service from Madison to Louisville. It was later absorbed by Greyhound Lines. Service to Indianapolis was provided by White Star Lines, a Madison company operated by Blink Lockridge of Madison. White Star remained in business until the 1980s.

Getting around Madison was fun for kids who could "hitch" a ride on the mule-drawn wagon of Archie Lewis, shown in this 1927 photograph on Main Street near Jefferson Street. Note the jail in the background. Lewis, who was a familiar figure around town, did general hauling and junk collecting. His wagon was often seen slowly working its way up the Michigan Road Hill, a trip that took nearly half an hour.

A summer trolley car passes the National Branch Bank and Masonic temple building on Main Street in this c. 1915 photograph. In peak times, trailer cars were added to increase seating capacity. The line ran from the western city limits to Walnut Street, where it branched north. Today a bench seat from the trolley, a relic of Madison's trolley days, sits outside the Elk's Club on West Street.

Miss Lydia Martin

Miss Addie Douglass

Miss Rosa Caplinger

Miss Emma Meyer

Miss Beatrice Garlinghouse

The mule-drawn streetcar line was electrified in 1898, and the new larger electric trolley cars required both a motorman and conductor. These lady trolley car conductors were featured in an 1899 special edition of the *Madison Democrat* newspaper. Perhaps a first in the women's liberation movement, the young ladies performed a job usually done by men, collecting the 5¢ fare and enforcing the rules, one of which was no smoking (and reportedly largely ignored). How long the ladies held this position is unknown. Another conductor's duty was to reset the trolley pole when it occasionally bounced off the overhead trolley wire where the line was bumpy with age. Trolleys served Madison until the growing popularity of the automobile and the loss of patronage during World War I caused its demise in 1919.

A thirsty horse team pulling a heavy hay wagon stops for a drink at a public trough along the Madison-Hanover Road (now Route 56). Water troughs along roads were common, especially along the steep roads like Michigan Road and Hanging Rock Hill Road, which often took half an hour to reach the top—a journey that nowadays takes two minutes by car.

This popular early-1900s bird's-eye-view postcard taken by Herbert Flora shows the old Canaan Road as it winds its way north from Madison through the scenic Crooked Creek valley. Visible in the foreground are the buildings of the Madison Glue Company. To the left is St. Joseph's Cemetery at the foot of Hatcher Hill. In the early 1960s, the road was rebuilt into the four-lane U.S. 421.

A historic marker commemorating the southern terminus of the Michigan Road was unveiled during the 1916 Indiana centennial celebration. Pictured at the unveiling are, from left to right, Elizabeth Barber, Margaret Rea, Ellen Garber, Mary Kealty, and Mary Goode Garber. Envisioned as a link between the Ohio River and Lake Michigan, the road was begun in 1828 and took nearly a decade to complete. The marker is seen today at West and Milton Streets.

Hanging Rock Falls on Hanging Rock Road (now state Route 7) was a popular tourist site when the steep, unpaved road curved beneath the picturesque waterfall. Barely visible around the curve in this early-1900s photograph is the buggy of photographer Herbert Flora. When the road was paved in the 1930s, the curve was altered to pass around the falls and today is occasionally closed after heavy rainfall floods it.

The Dixie Flying Service was located at the Madison Airport on the southwest corner of Michigan Road and Clifty Drive. It operated a school for pilots and mechanics, drawing students from throughout the country. Pictured in this photograph of the 1932 class, Clyde Beyer (first row, far left) was from Pittsburgh, Pennsylvania. Cleone Grimes, a local girl, was the school's mascot with whom everyone was enamored. (Courtesy Clyde Beyer.)

The final way of getting around Madison often was a ride in the back of the funeral hearse of the Vail Furniture and Undertaking Company. Parked at a hilltop residence in this c. 1920 photograph, the hearse has ornately draped, side display windows reminiscent of the old, horse-drawn hearses. Unusual for a hearse, it was painted white rather than the traditional black.

Ten

PEOPLE AND PLACES

Author David Graham Phillips, born at 201 East Street in Madison, wrote best selling novels. His book *Susan Lennox: Her Fall and Rise*, which became a film starring Greta Garbo, was based on an incident that happened in Madison. Phillips, who wrote 26 best sellers, was murdered in Gramercy Park in New York City in 1911 by a man who believed that Phillips had slandered his family in one of his books. Phillips often wrote standing up, as he believed that he thought better doing so, often for 12 to 16 hours at a time.

Miss Drusilla Lanier Cravens sits on her veranda at Cliff House in this 1945 photograph. Born in 1864 and nicknamed "Miss Doot," she was the 10th child out of 12, in one of the wealthiest and most prominent families of Madison. Her mother was a daughter of J. F. D. Lanier and her father was prominent attorney and judge John R. Cravens. She was an avid local historian and philanthropist.

Cliff House, an 1885 mansion located at the top of Michigan Road Hill, was purchased by Miss Drusilla Lanier Cravens in 1906. She added the veranda and Doric columns, perhaps as a reminder of her travels to Europe where she studied piano with Franz Liszt and learned art. In her lifetime, Cravens purchased and restored a number of other hilltop mansions and was instrumental in transforming the J. F. D. Lanier Mansion into a museum.

Dr. William Davies Hutchings, shown in this 1861 daguerreotype, was the epitome of a horse-and-buggy doctor. He was granted a medical diploma from Indiana Central Medical College, now DePauw University. He practiced medicine in Madison from 1876 to 1903, and his medical records and instruments make one of the best 19th-century collections in the country. His office and dispensary are now a museum owned by Historic Madison, Inc.

The office of Dr. William Davies Hutchings is located at 120 West Third Street. The building (center in photograph) is an example of early Greek Revival–style architecture. After Hutchings's death in 1903, his daughters closed the office doors, leaving all of his equipment and belongings intact. The office stayed sealed for nearly 70 years when the doctor's granddaughter donated the property to Historic Madison, Inc. (Courtesy Historic Madison, Inc.)

This 1900 photograph shows, at age 14, Madison native Rachel Hoffstadt, who later earned a doctor of philosophy from the University of Chicago and a doctor of science from John Hopkins University. She was the first Hanover College graduate to receive a doctorate. A professor of microbiology at the University of Washington in Seattle, she was an early investigator in the use of oral vaccines for the treatment of typhoid fever.

This early-1900s postcard view was taken looking east on the 600 block of East Second Street, where two residents stand at their front gates. The young lady's house with the Ionic columns (far left) was later razed and replaced by the large, prairie-style home seen today. At the curb of the unpaved street is a stone step, placed to help the ladies up into their buggies.

Virginia-born Jeremiah Sullivan arrived in Madison in 1816, where he started a family and set up a law practice. He became involved in politics, serving in the state legislature and sitting on the Indiana Supreme Court. Hanover College and the Indiana Historical Society count Sullivan as a founder. Credited with naming the city of Indianapolis, he is the patriarch of a family whose influence can be felt today.

In 1818, Jeremiah Sullivan built this house located at 304 West Second Street. It is said to be one of the best examples of Federal-style architecture in the Old Northwest Territory. The house features a serving kitchen and basement cooking kitchen with brick floor and stone fireplace. The Sullivan family lived in the home for over 70 years. The house is now a museum owned by Historic Madison, Inc.

The Greek Revival Colby-Jeffrey House, at Second and Elm Streets, was built in the 1830s for Daniel Colby, who left town before its completion. It is said that J. F. D. Lanier stayed here while his nearby residence was completed. In its lifetime, it has seen several uses, for a time as the historical society museum and, as in this 1920s photograph, the Colonial Inn Hotel. Today it is again a private residence.

The home of the Honorable Hiram Francisco, located at 212 West Second Street, looks today very much like it did when this photograph was taken in the early 1900s. Francisco, a prominent attorney in Madison, also served as a circuit court judge in Jefferson County. Shown in the photograph are Judge and Mrs. Hiram Francisco with their daughters Helen, Martha, and Georgeanne.

Hollywood movie star Irene Dunne lived in Madison, attended St. Michael's Church, and graduated from Madison High School in 1916. Dunne, nicknamed "Dunnie," resided at 916 West Second Street with her mother and grandfather, and dated Dana Vail, whose family owned the Vail Funeral Home. She made her show biz debut in school plays and went onto an outstanding acting career, starring in over 40 films.

A group of old-timers loaf on what is referred to as the "liar's wall" in front of the Jefferson County Courthouse, telling stories from their past. The wall was so called because many of the stories told may have stretched the truth just a bit. This corner of the courthouse lawn once held a cannon, later scrapped for wartime metal needs. Today there is a miniature Statue of Liberty.

The Madison Hotel was located at Second and Mulberry Streets. Designed by Madison architect Francis Costigan, it was built in 1850 and later, for a time, became a girls school. Renovated in 1883, it reopened as the finest hotel in Madison. Razed in 1949 for construction of a supermarket, the decorative ironwork by the front door in this 1927 photograph is today in the north garden of the J. F. D. Lanier Mansion.

The man in this 1890s photograph is wetting the dirt street to keep the dust down and perhaps touting the fact that he has indoor plumbing. The ornate iron fence behind him was produced in Madison by the Cobb, Stribling and Company foundry and was so popular that the design was patented. Madison was known for its ornate wrought iron work, which rivaled that of New Orleans.

Maj. Edward G. Niklaus wears his ceremonial uniform of the Knights of Pythias in this photograph by Madison photographer Joseph R. Gorgas. Niklaus, a prominent businessman, was active in politics and civic affairs and was for a time U.S. postmaster in Madison. A life-size portrait of Niklaus based on this photograph was painted by William Mckendree Snyder and is today displayed at the Jefferson County Historical Society.

Edward Niklaus operated one of the largest wholesale grocery businesses in southern Indiana, at 301–307 West Main Street. The original building, seen to the right in this 1870s photograph, was razed in 1884 and replaced with a new and larger structure. It is known today as the Scott Block building. An 1899 advertisement shows that Niklaus sold coffee, teas, sugar, spices, fine wines, whiskies, and tobacco.

125

Railroad president John Brough built this three-story brick home in 1851 on a 10-acre estate on Michigan Road. The stately mansion was elaborately furnished with such accoutrements as French gilt chandeliers, pier glass windows, and bell pulls to call servants. John Cravens purchased it from Brough in 1855 and named it Cravenhurst. Today, greatly altered, it is owned by the Loyal Order of Moose.

The Honorable John R. Cravens graduated from Indiana University in 1838 at the age of 19. He became a lawyer, a state senator, and a railroad executive, and he was appointed a circuit court judge in 1873. During the Civil War, he served with the Army of the Potomac at the siege of Knoxville. In 1844, he married Drusilla Lanier, daughter of J. F. D. Lanier, and raised a large family at Cravenhurst.

Robert J. Elvin stands outside his home at 727 West Main Street for this 1880s photograph taken by William Heberhart. Elvin was employed by the Madison and Indianapolis Railroad from its beginning in 1837 until his death in 1901. He served in various railroad positions including paymaster and general agent and was an avid collector of historical railroad artifacts and documents, which are treasured today.

This lithograph shows the J. F. D. Lanier Mansion as it appeared when occupied by Lanier's son Alexander. J. F. D. Lanier moved permanently to New York in 1851 and under the guidance of Alexander, the mansion became a garden showplace. Visible are the formal gardens, outbuildings, and greenhouses that once graced the estate. J. F. D. Lanier remained an important factor in Indiana, financing railroads and aiding the state when it faced bankruptcy during the Civil War.

Across America, People are Discovering Something Wonderful. Their Heritage.

Arcadia Publishing is the leading local history publisher in the United States. With more than 3,000 titles in print and hundreds of new titles released every year, Arcadia has extensive specialized experience chronicling the history of communities and celebrating America's hidden stories, bringing to life the people, places, and events from the past. To discover the history of other communities across the nation, please visit:

www.arcadiapublishing.com

Customized search tools allow you to find regional history books about the town where you grew up, the cities where your friends and family live, the town where your parents met, or even that retirement spot you've been dreaming about.